To Natalie

Because I Love you

AND Because

You can do all

things!
Love,
Oma
10/27/14

YOU CAN DO
All Things

Published by Mango Publishing Group, a division of Mango Media Inc.

Cover + Interior Illustrations: Kate Allan

Layout Design: Elina Diaz

Mango is an active supporter of authors' rights to free speech and artistic expression in their books. The purpose of copyright is to encourage authors to produce exceptional works that enrich our culture and our open society.

Uploading or distributing photos, scans or any content from this book without prior permission is theft of the author's intellectual property. Please honor the author's work as you would your own. Thank you in advance for respecting our author's rights.

For permission requests, please contact the publisher at:

Mango Publishing Group
2850 Douglas Road, 3rd Floor
Coral Gables, FL 33134 USA
info@mango.bz

For special orders, quantity sales, course adoptions and corporate sales, please email the publisher at sales@mango.bz. For trade and wholesale sales, please contact Ingram Publisher Services at customer.service@ingramcontent.com or +1.800.509.4887.

You Can Do All Things: Drawings, Affirmations and Mindfulness to Help with Anxiety and Depression

Library of Congress Cataloging

ISBN: (print) 978-1-63353-862-7, (ebook) 978-1-63353-863-4

Library of Congress Control Number: 2018957579

BISAC category code: SELF-HELP / Motivational & Inspirational

Printed in the United States of America

YOU CAN DO
All Things

DRAWINGS, AFFIRMATIONS AND MINDFULNESS
TO HELP WITH ANXIETY AND DEPRESSION

KATE ALLAN, CREATOR OF THELATESTKATE

 mango

CORAL GABLES

Praise

"Anxiety, stress, and depression can put a damper on anyone's day. This is why a daily mindfulness practice is a must in today's fast-paced stressful world. Kate Allan's *You Can Do All Things* combines wisdom, humor, and beautiful, whimsical artwork that can be your daily companion when you feel anxious, inadequate, and overwhelmed. Spending a few minutes every day meditating on TheLatestKate's illustrations and words of wisdom offer encouragement that you can face any challenge that crosses your path. This is a book to open and use over, and over, and over again—a true testament that you are not alone."

—Susyn Reeve, author of *Heart Healing: The Power of Forgiveness to Heal a Broken Heart*

"Kate Allan's artwork has always had an incredible positive message that I can't help but love—and now it's in book form! As soon as I heard she was putting together a book, I couldn't wait to get my hands on it. It's full of beautiful art and encouraging messages that help me to calm my anxiety and get through even the hardest of days."

—Becca Anderon, author of *Think Happy to Stay Happy*

"I see myself in so much of Kate's writing—and yet, I haven't been able to pinpoint and put into words these hurts before. Which to me may be the ultimate sign of an incredible book: when the author articulates something you feel so acutely in your own heart, but haven't been able to clearly express or truly grasp. In fact, I had many *a-ha!* moments while reading this beautiful book. I especially love Kate's hopeful, unique take on hopelessness, and her nuanced view of feeling unworthy in relationships. These insights can have a profound effect on our lives and on our days. Because once we understand ourselves better, we have the power to support ourselves, to find what we need, one step at a time.

Through her honest words, uplifting illustrations, and actionable suggestions, Kate also encourages us to keep trying and to keep going. She reminds us that we can indeed persevere, even when things are seemingly awful. *You Can Do All Things* is like a best friend: real, raw, and generous in its support. It is a book that says, 'I hear you,' and 'I'm here for you.' It is a book that says, 'Yes, you are strong and capable, whether you feel it or not.' "

—Margarita Tartakovsky, PsychCentral

Contents

Foreword

When you have anxiety or depression, you can feel deeply alone. You can feel like you're the only person on the planet who's struggling with weird worries (which won't go away), who can't go grocery shopping without getting sweaty and panicked, who fears everything.

Everything.

You can feel like you're the only person on the planet who has an unrelenting, persistent kind of pain, who feels hollow, who feels like the teeniest tiniest task takes all you have—and you don't really have much.

And you hate yourself for it. For all of it. You think you're a loser and a weakling. You're convinced of it. You think there's something inherently wrong with you. And all you yearn for is to be "normal."

When we feel this way, one of the greatest gifts we can receive is knowing that there's someone out there walking a similar path, someone who understands the sorrow, the struggles, the symptoms, the hardships. Someone we can relate to, someone who shares their story, with vulnerability and without filters.

With *You Can Do All Things,* Kate Allan has given us such a gift. In *You Can Do All Things,* Kate shares her struggles with anxiety and depression, which started when she was just a child. She delves into other crushing aches, such as self-loathing and hopelessness, which sadly often accompany anxiety and depression.

I see myself in so much of Kate's writing—and yet, I haven't been able to pinpoint and put into words these hurts before. This to me may be the ultimate sign of an incredible book: when the author articulates something you feel so acutely in your own heart, but haven't been able to clearly express or truly grasp.

In fact, I had many *a-ha!* moments while reading this beautiful book. I especially love Kate's hopeful, unique take on hopelessness, and her nuanced view of feeling unworthy in relationships. These insights can have a profound effect on our lives, on our days. Because once we understand ourselves better, we have the power to support ourselves, to find what we need, one step at a time.

Through her honest words, uplifting illustrations, and actionable suggestions, Kate also encourages us to keep trying and to keep going. She reminds us that we can indeed persevere, even when things are seemingly .

You Can Do All Things is like a best friend: real, raw, and generous in its support. It is a book that says, "I hear you," and "I'm here for you." It is a book that says, "Yes, you are strong and capable, whether you feel it or not."

You Can Do All Things is a book you pick up when you need to remember that you are indeed worthy, even and especially as you're struggling and questioning yourself, and yearning not to struggle.

Drawing and writing are a vital part of Kate's coping toolkit. In addition to using her illustrations as encouragement, we can use them as inspiration to create something of our own. Because when we use our voices, we not only express what's swirling inside our hearts and souls, but we also stake our claim. We speak up for ourselves. And that is powerful. We tell ourselves: *My struggles are real. They are valid. But they do not define me. I am so much more.*

I am grateful to Kate for sharing her story and reminding us of this very fact. And I will keep her book close by for the days when I inevitably forget.

Margarita Tartakovsky, MS, is a writer and associate editor at PsychCentral.com, the internet's largest and oldest independent mental health online resource. There, she pens pieces about everything from anxiety and ADHD to creativity and couples to self-compassion and self-care. She also regularly contributes to Spirituality & Health *online. She lives in Florida with her husband, Brian, and their daughter, Lily.*

Introduction

It's story time. Are you ready? Grab a cuppa and cozy up. This isn't a very happy story, but it's mine, and I'd like to share it with you.

My life has taken a lot of twists and turns, generally in the mental health sense. When I was young I had a hard time functioning. I was constantly overwhelmed and wholly confused about how to be "normal." What I didn't know was that I was experiencing an unusual childhood; I was raised, mostly unschooled, by strict religious parents and also struggled with an undiagnosed anxiety disorder.

At age seven my parents enrolled me in public school, and boy was that a doozy. While somewhat literate, I'd never learned phonics, and so I had to relearn how to read. And though I'd interacted with kids my age in my church group, I had known them all since I was a baby, so I had no idea how to make friends. I was entirely unequipped to take on a chaotic playground environment. Half-deaf, tearful, and shy, I decided at the very least, that I was going to figure out how to be "normal," and at most, very possibly succeed.

By third grade I figured out phonics (thanks, Mrs. Merdian) AND how to make friends. Evidently, all you had to do was go up to another kid and do the thing they were doing. You say something like, "this marker smells funny," and they

say, "yeah it does," and then BAM, you're friends! There was no cure for the half-deafness, but I figured out that if you tell everyone you don't have sound direction, they *sometimes* remember and don't get frustrated with you (this has about a 20 percent success rate, but, you know, it's something). The most important lesson I learned was to recognize and diagnose the problem. Once you know exactly what you're facing, you can at least attempt to fix it.

So, elementary school, figured out and taken care of, cool. But then puberty happened. And my brain just decided, HEY. LET'S MAKE DEPRESSION HAPPEN. LET'S MAKE IT HAPPEN CONSTANTLY. The unfortunate thing about depression is that it's REALLY hard to recognize and diagnose the problem. I mean, if you've experienced it, you know that. Everything that went wrong felt like my fault. I didn't realize I had a mental illness, I just thought I was broken. "Why can't I feel happy?" I'd ask myself. I felt so much shame and frustration.

Unaddressed depression and anxiety caused a slow downward spiral in my life. I felt disconnected and alien, and as school became more intense and stressful, I began having daily panic attacks. By my sophomore year of high school I had become "homeschooled" which really just meant I got permission from my parents to drop out. I got a GED (A "Good Enough Diploma," as coined by Chris Rock), but this meant I no longer needed to be anywhere. I slowly lost contact with my friends and grew to feel very isolated. Unmotivated and directionless, I fell behind on academics and slipped into a deep pit of self-loathing.

Having difficulty meeting expectations and also struggling with a strong sense of self-disgust was basically the theme of my teens and early twenties. I didn't understand how others were so engaged, bold, interested, happy, and alive. I walked around with a virtual smiling mask on, trying to fulfill society's requirements. I got my driver's license later than average, dated later than average, attended college later than average, and took much longer than most to get my degree. The world felt dangerous and to me, it was just a rule written in the rulebook of the universe that success and happiness were unequivocally out of my reach.

So what changed? One day while I was browsing the internet, I came across a comic about mental illness by the artist Ruby Elliot. Her succinct portrayal of the hopelessness and self-loathing that characterized depression helped me to realize that I was far from alone in how I was feeling. This led me to draw my own struggles as well, which filled me with a small sense of purpose.

After discovering an artist who knew the hardships I was facing, I searched online for a mental illness community and luckily, I found a wonderful one. There were people online talking about having difficulty leaving their houses, how lonely one can feel when they're socially anxious, how life often felt meaningless, how they had a hard time looking in the mirror and not being flooded with self-abusive thoughts. Several people mentioned what they were covering in therapy, and I decided I should give it a shot.

I found a kind psychologist who rather quickly diagnosed me with Generalized Anxiety Disorder. And while for most people that would be cause for concern, for me, it was entirely validating and relieving. Having a name for my struggles allowed me to communicate, gave me access to actual helpful treatment and coping skills, and enabled me to find others experiencing similar difficulties. I discovered that my anxiety and depressive experiences were often linked—that if I was feeling fearful and overwhelmed, my mind often defaulted to "the situation is hopeless" and severe depression symptoms would arise. I further discovered that drawing cute animals and writing encouragement helped me cope. And if I could figure out tricks and ways to combat my brain's misbehavior, I felt it important to share it with others too.

So, that's what brings us to this, *You Can Do All Things* book. This is a guide I wrote for younger Kate, the person who hated herself and had no idea how to cope with what troubled her. I've included every strategy, affirmation, and coping skill that has gotten me through hard times, from slight worries about how well I'm doing, to incessant suicidal ideation.

Because the truth is, sometimes it feels impossible to do the little things. I mean, I've been there. While you're reading this, I'm probably having a breakdown in preparation for an email I have to write. But I CAN tell you I will actually write it. And that's what this book is about, accomplishing things when you feel like you can't. While it is by no means a complete view on fixing anxiety and solving the mystery of depression, this book is a summary of lessons I've learned and techniques I've used to break through the roadblocks my mind builds in front of

itself. These illustrations will help you fight the voice that tells you you can't do things or that you shouldn't do anything. And, with effort and patience, you can in fact DO ALL THINGS.

So, if you experience rough days, please come along with me. I've organized this book into chapters for the things I've struggled with most. Each chapter features my story, an abundance of colorful and encouraging trees and animals, and coping tips that helped me the most when I was at my lowest.

The important thing I want you to know, reader of this book, is that you're never alone. There are thousands, if not millions of people out there struggling with the same things as you, whether it's loneliness, grief, self-hate, or difficulty finding purpose. I've hit rock bottom time and time again and through help from others and my own determination, I've climbed back up again. My hope is that, through sharing what I've learned, I can prevent others from going through the same painful experiences I've had. Creating artwork helps me and, I hope it helps you too.

CHAPTER 1

I'm Feeling Anxious

Feeling anxious is such a normal part of my life. It wasn't until relatively recently that I knew what it was like to not feel anxious every day.

When I was a little kid, I hardly ever felt safe. Whenever my parents would take me to a playground, I would hide under the jungle gym. My parents and teachers would try to introduce me to other children, and I couldn't speak to them. I was such a fearful kid that I would literally hang on to whoever was watching me unless I was in a place where I felt safe, and that was really only in my bedroom or at my grandparents' house. So, feeling anxious has just been embedded in my brain since I was a baby.

that's tough

I received a diagnosis for Generalized Anxiety Disorder when I was twenty-four years old, and that was important because at that time I wasn't functioning as an adult very well. I had pushed through my anxiety to the point where I was quasi-adulting. I could drive, have relationships, work, and attend community college classes, but I was constantly FULL of anxiety.

On "good" days I would come home mentally and emotionally drained. On bad days I would have panic attacks and emotional breakdowns that frequently led me to withdraw from classes and quit multiple jobs. And as icing on the cake, my relationships were also impacted because I was so emotionally high maintenance. I needed constant reassurance from others that, no, they weren't mad at me, and yes, we're still friends, yes, they still like me, etc.

I like you

So, what does anxiety feel like for me? On Tumblr it's described as "hearing the boss fight music but never finding the boss." It's a stressful and intense state of mind where everything feels dangerous or prone to disaster. No place or situation is ever safe, and no decision is a good decision. I feel a lot of worry, and I have perceptions that are skewed very negatively.

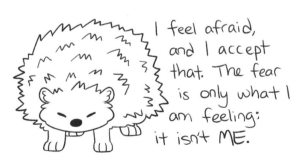

I feel afraid, and I accept that. The fear is only what I am feeling; it isn't ME.

The good thing to know about anxiety is that it's just one big mind game. The trick is to recognize it for what it is, and catch it early before it spirals into a panic attack. And even when panic attacks actually occur, you

can exercise mindfulness ("name the emotion, accept the emotion, understand the emotion is separate from you") and deep breathing to bring it all back down to reality.

And I don't mean to minimize anxiety; it still impacts my life daily. But, it does help me to understand that it's something that can be managed. I lived so long being controlled by my fears. I wish I had known sooner about mindfulness and Cognitive Behavioral Therapy, as they got me functioning again.

There is always hope. There are so many approaches to, and treatments for anxiety disorders that I feel confidently that ANYONE can be helped. No one has to be forever ruled by their fears.

You're safe. You're okay.

Anxiety
lies.

There is
no doom
incoming,
and you're
managing
everything
just fine.

How many times have you felt like things were out of control and then everything worked out fine?

YOUR ANXIOUS FEELINGS AREN'T INDICATIVE OF REALITY.

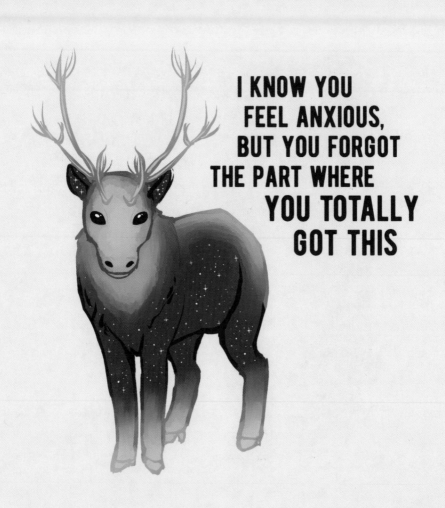

It's okay to
be scared.

It's okay to be
uncomfortable.

You will succeed
in spite of those
feelings.

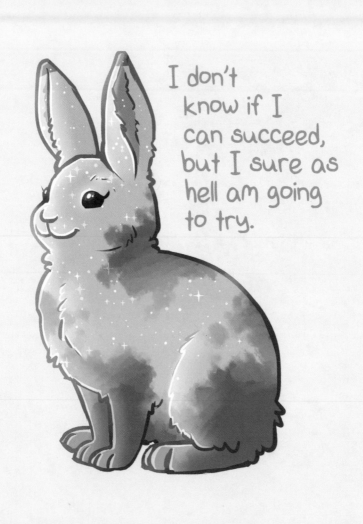

I don't know if I can succeed, but I sure as hell am going to try.

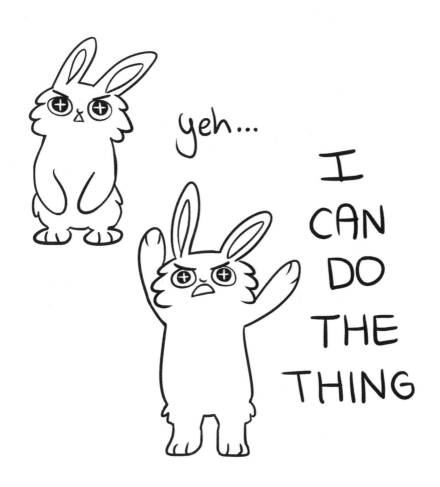

IT'S OKAY TO BE AFRAID, BUT AS MUCH AS YOU CAN, ACT FROM LOVE RATHER THAN FROM FEAR.

you're
going
to get
through
this okay

Whatever happens today, you will make it through.

You are doing enough.
It's going to be okay.

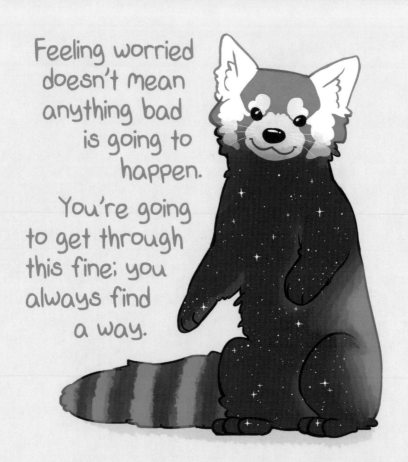

Everything
is scary and you
feel vulnerable,
but that doesn't
mean anything
is going to
go wrong.

Anxious
feelings aren't
usually indicative
of reality.

The past is painful,
the future is uncertain,

let's just live
for right now.

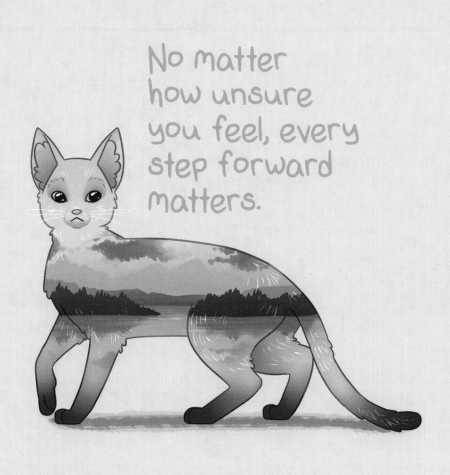

No matter how unsure you feel, every step forward matters.

it will all
work out
somehow

just try
to stay calm
and do
what
you
can

it's all going to work out fine

If you are struggling with anxiety, I invite you to try one of these coping strategies that have worked for me:

Exercise
Even a short walk
can help

Rest
Give yourself plenty of
time to unwind and sleep

Eat Something Healthy
Your body getting the fuel
it needs will help your
mind function better

It's never
too late
to change
your life.

it's never
too late

for a
new start

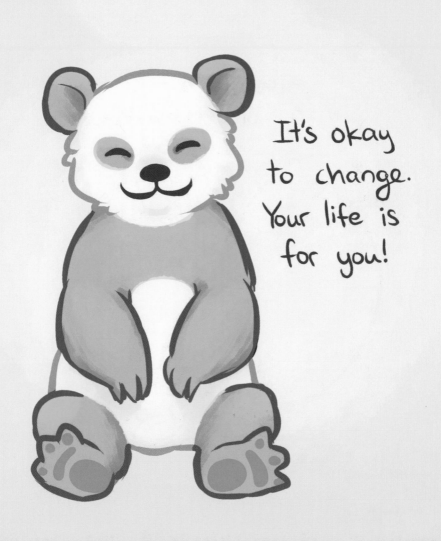

It's okay
to change.
Your life is
for you!

Today is a
brand new day,
and you are a
brand new you.
Good luck!

CHAPTER 2

I'm Feeling Inadequate

sigh

I'm going to be blunt with you here: I have rarely felt qualified for ANYTHING. So we are coming at my story from the perspective of, "I have always felt inadequate at everything that I have tried to do," and you know what my trick is? It's saying to myself, "Hey, you *never* feel like you're good enough; you *never* feel qualified, but you always manage a way through anyway."

Impostor Syndrome: A feeling of self-doubt, insecurity, or unworthiness of your accomplishments. This is often accompanied by a fear of being exposed as "a fraud."

I think you're pretty great

When I was in college, I worked for a while as an English tutor, which is kind of funny because I didn't feel qualified to write well, I didn't feel qualified to explain things to other people, and I didn't feel qualified to handle customer service, but I knew I wanted the job. So, despite all my trepidations, I went for the position anyway. And you know what? It went well. The students appreciated

my help. My boss was satisfied with my work. Despite my low self-esteem, I had a really good time working there. And I wonder how my life would be if I always had listened to that negative voice in my mind.

In relationships it's been tricky because I rarely feel worthy of love or worthy of anyone's attention, and so I feel like I'm always taking up people's time that is better spent elsewhere, or that I am not entertaining enough, or that a relationship with me doesn't have enough positives. The only way that I get through that is by focusing on the other person and trying to make them happy. I have to actively acknowledge that my feelings about my worthiness are not important; turning my focus outward is going to make for a healthier relationship.

Common Causes of Low Self-esteem:

1. Disapproval by Authority Figures
2. Uninvolved or Preoccupied Caregivers
3. Bullying
4. Academic Difficulties
5. Trauma
6. Restrictive or Unforgiving Belief Systems
7. Society and the Media

rough stuff

So, what can be done? I have been helped by these things:

- ♥ Choosing to be my authentic self; not reshaping myself to fit someone else's standard, whether that's my physical appearance or behavior.

- ♥ Only embracing relationships where I am respected and accepted for who I am.

- ♥ Being honest with myself and my loved ones about my insecurities and challenges; owning it.

- ♥ Showing the kindness and understanding to myself that I would show a friend.

- ♥ Reframing: looking at past events and choices with understanding and compassion and without judgment.

The conclusion I have come to is that feeling inadequate doesn't really mean anything, it's just another lie our brain tells us. Maybe it's a bizarre way to try and keep us safe from risks or failure. Really though, all it apparently does is keep us from realizing our potential and makes us feel bad about ourselves. Thanks, brain.

No negativity today;

YOU'RE GETTIN' WORK DONE!

you're
strong
smart,
and
you
got
this

struggling
does
not
automatically
mean
failing.
you're
doing
just
fine.

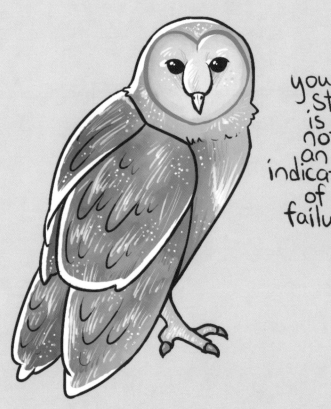

your
struggle
is
not
an
indication
of
failure

You're not going
to succeed at everything
you try, and
that's okay.

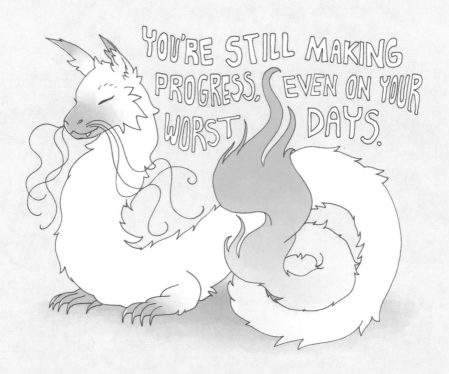

there is no one **PERFECT** way.

You're doing just fine.

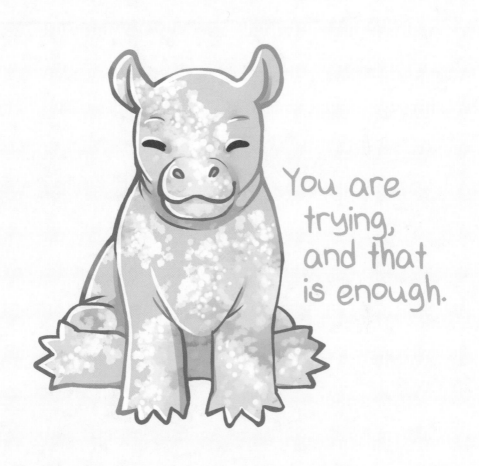

You are
trying,
and that
is enough.

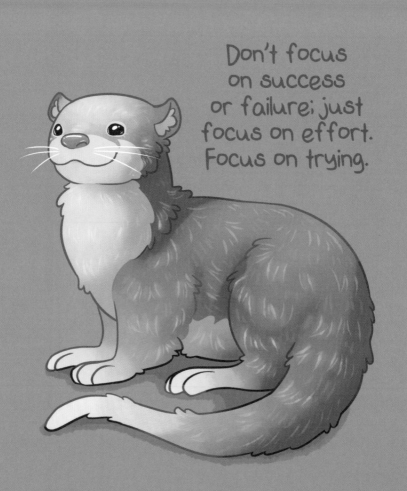

Don't focus on success or failure; just focus on effort. Focus on trying.

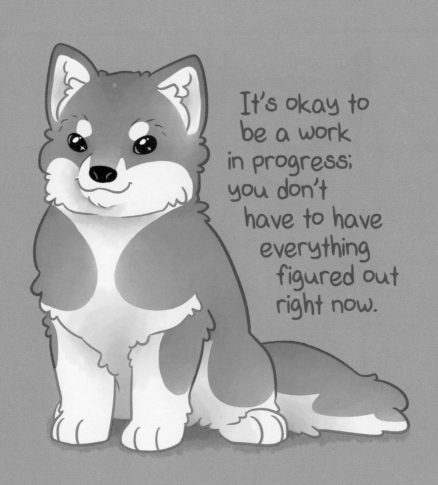

It's okay to be a work in progress; you don't have to have everything figured out right now.

No one else knows what they're doing, either. It's all going to turn out fine.

You're the only one paying so much attention to your mistakes.

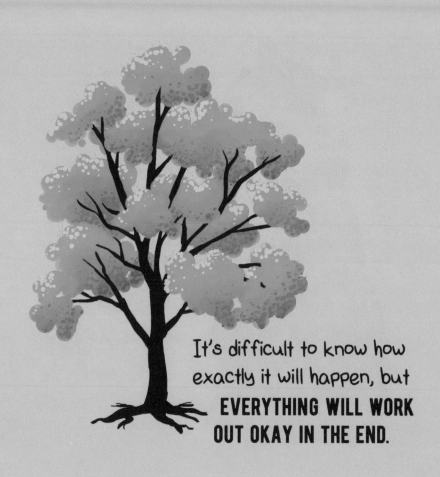

It's difficult to know how exactly it will happen, but **EVERYTHING WILL WORK OUT OKAY IN THE END.**

If you are struggling with feeling inadequate, I invite you to try one of these coping strategies that have worked for me:

Consider the Concept of Wabi-Sabi
"There's beauty in imperfection"

List Five Things You Accomplished Recently
No matter how small

Tell Yourself It's Easy
A simple and effective brain hack

you
deserve
good
things

you deserve
to rest

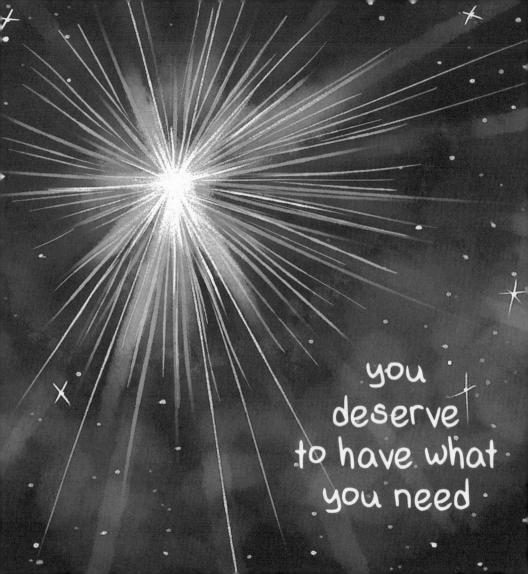

CHAPTER 3

I'm Feeling Down on Myself

I don't know about you, but the negative voice in my head is STRONG. I have a seemingly endless stream of abusive thoughts.

This started when I was very young. I was an anxious kid, which meant I had a hard time making friends, and I was very nervous about being away from my caregivers. This frustrated my teachers and church leaders, and they labeled me as a problematic kid.

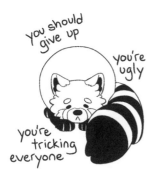

Where Self-Hatred Occurs:

1. When a person perceives a defect in themselves that differentiates them from their social group

2. When a person's self or actions conflict with their standards (Shame)

3. When a person feels they have violated a moral standard (Guilt)

I wish adult me could talk to that little kid and let her know she was a good kid. That the anxiety she felt couldn't hurt her, and the way adults reacted to her were their issues, not reflections of baby Kate's worth as a person.

Some psychologists refer to this as "caring for your inner child." I honestly have no idea how credible it is, but it's an interesting approach, isn't it? Can we cure our self-abuse by caring for the battered, vulnerable parts inside of us?

In any case, I like the idea of treating yourself as you would treat a friend. Would you ever talk to your friend the way you speak to yourself? The truth is you deserve just as much kindness and compassion as you show others. You're not exempt just because you can see all the ugly parts of yourself.

When I started The Latest Kate as an illustrative project to document my depression, I was sure I would receive lots of negative feedback. And you know what I have strangely found? When I have opened up to others about my difficulties and insecurities, people responded with kindness. People shared with me that they shared the same struggles. Rather than finding disgust, I found community.

Sometimes the most vulnerable parts of you are the most relatable. Sometimes they're the most beautiful.

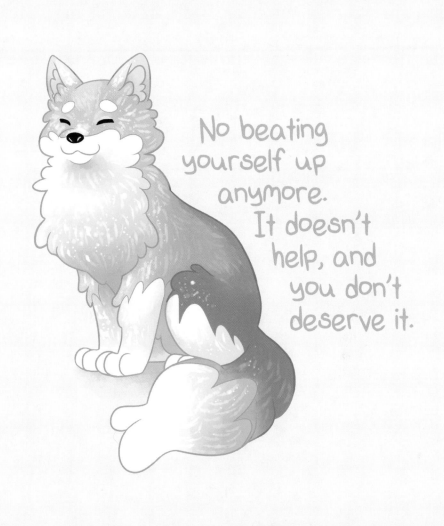

No beating yourself up anymore. It doesn't help, and you don't deserve it.

Here's a friendly reminder that the negative voice in your head is **not** you, and you are actually completely delightful.

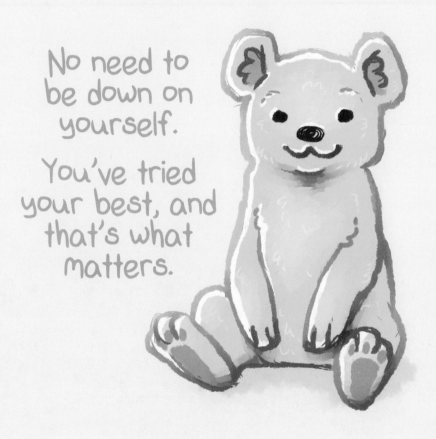

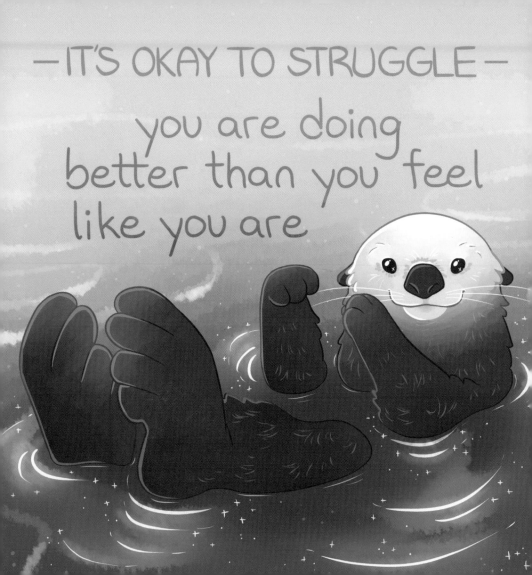

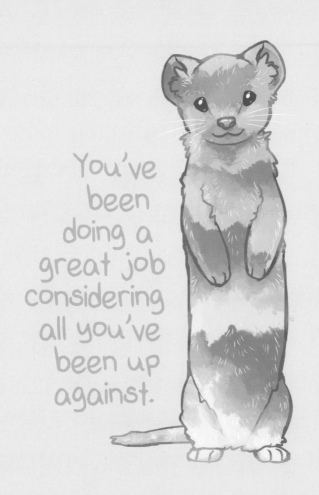

You've been doing a great job considering all you've been up against.

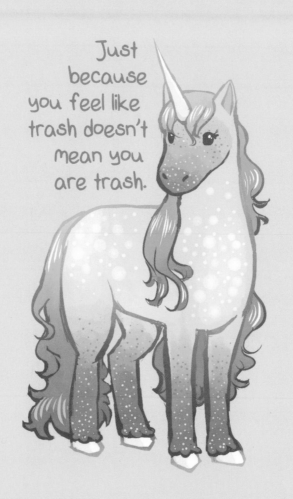

The negative voice in your head isn't worth your concern. No need to care,

HATERS GONNA HATE.

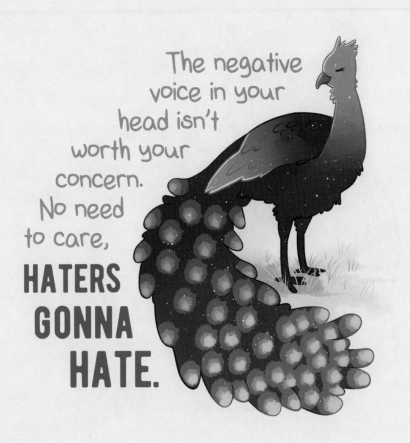

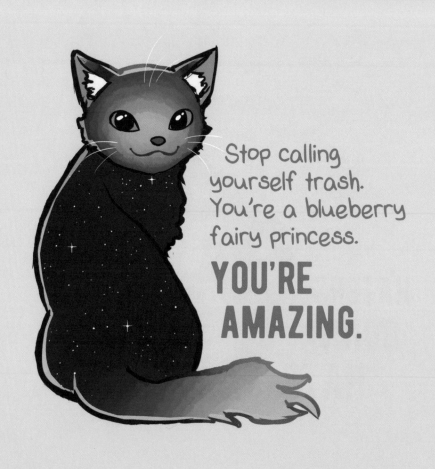

you can always afford to be a bit KINDER to yourself

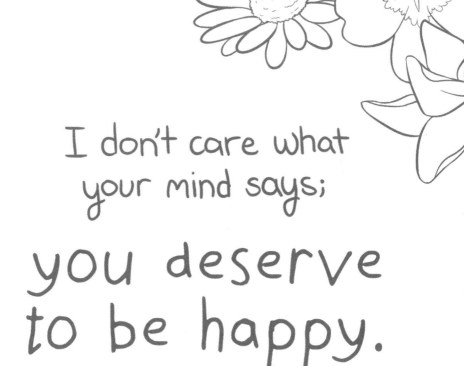

I don't care what
your mind says;

you deserve
to be happy.

you're
doing
a great
job

mistakes
are fine

they don't
make you
a bad person

relapse

does not erase

your successes

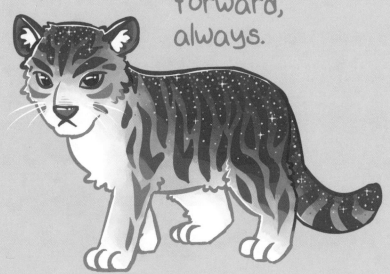

You can't change anything about the past.

Focus on moving forward, always.

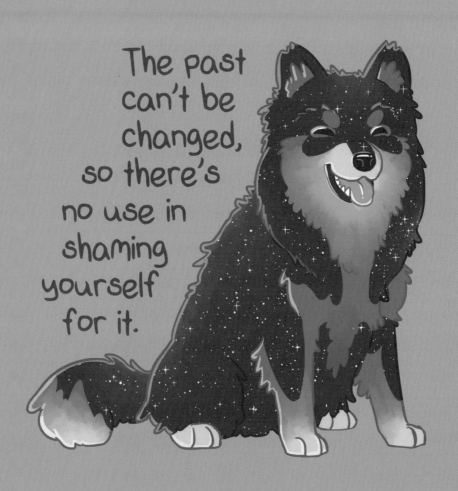

The past can't be changed, so there's no use in shaming yourself for it.

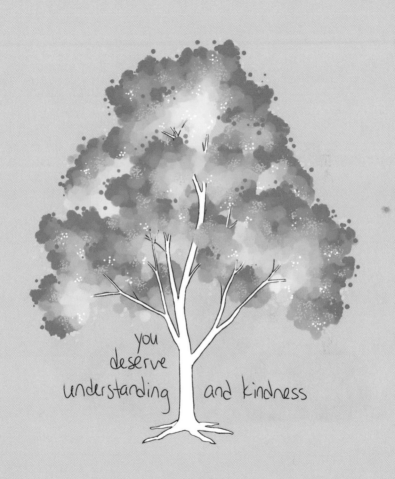

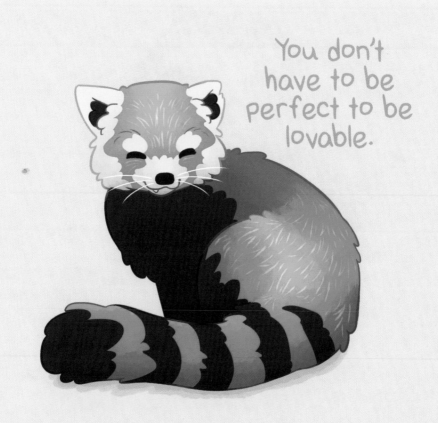

You don't have to be perfect to be lovable.

you are
lovely
just as
you are

You aren't "too much" of anything. You are just right as you are.

YOU'RE JUDGING
YOURSELF
TOO HARSHLY
YOU'RE DOING
FINE

numbers do not decide your worth as a person

you are made
of star stuff.

you are beautiful.

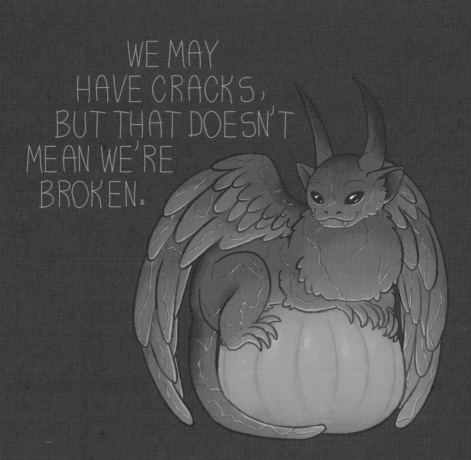

WE MAY
HAVE CRACKS,
BUT THAT DOESN'T
MEAN WE'RE
BROKEN.

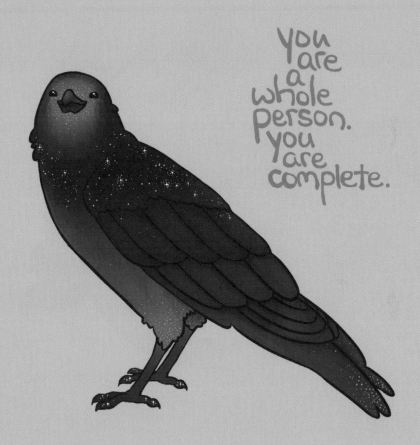

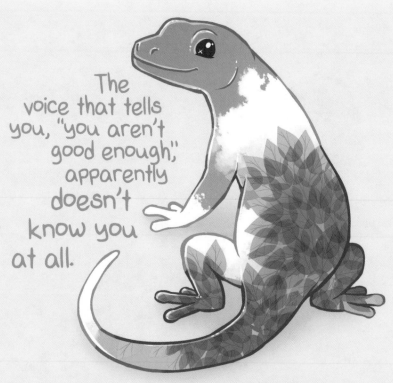

The voice that tells you, "you aren't good enough," apparently doesn't know you at all.

You're amazing.

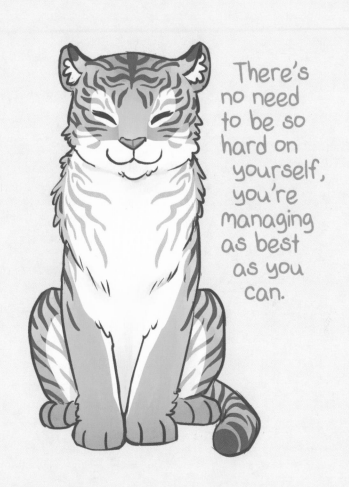

There's no need to be so hard on yourself, you're managing as best as you can.

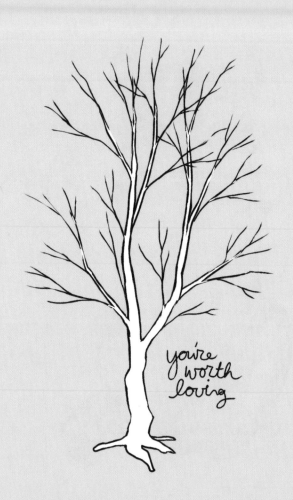

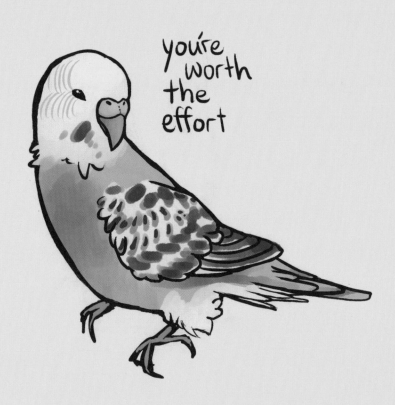

you're
worth
the
effort

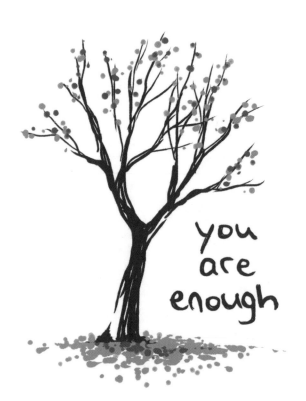

you
are
enough

If you are struggling with self-loathing, I invite you to try one of these coping strategies that have worked for me:

Note Progress

Value every step forward

Take a Break From Social Media

People only shine a light on things they want you to pay attention to, and those things are not always honest or helpful to see

Replace Negative Self-Talk with Positive Mantras

"I am failing" can be replaced with "I am doing all that I can"

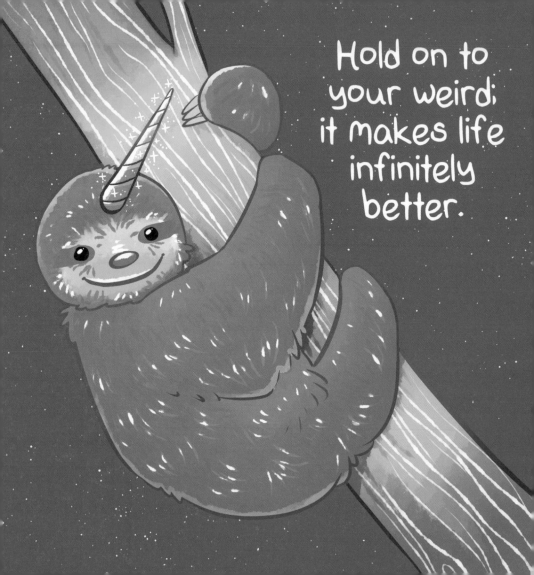

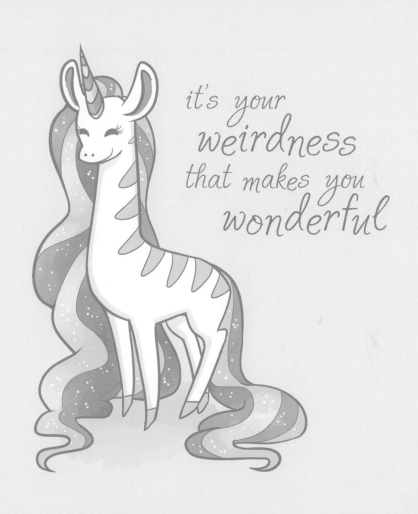

it's your
weirdness
that makes you
wonderful

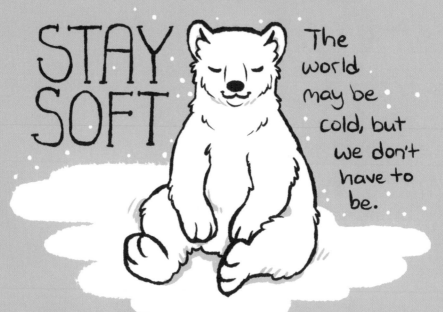

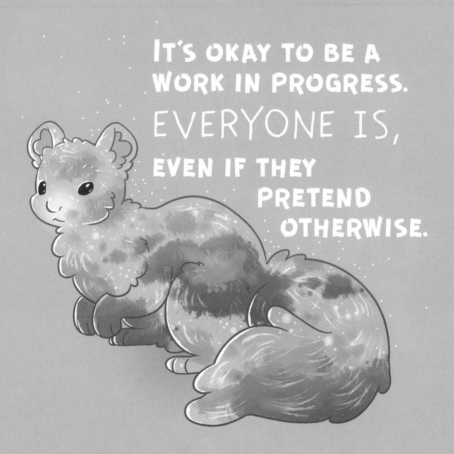

It's okay to
float along.
It's okay to
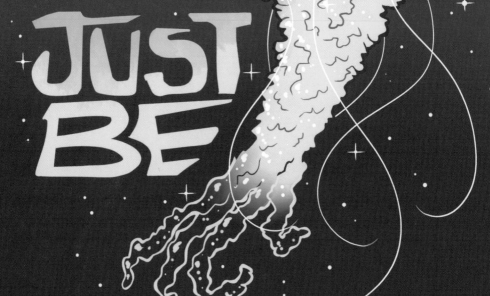
JUST
BE

I'm Feeling Overwhelmed

Being overwhelmed is a very common feeling with anxiety, isn't it? It kind of just goes hand-in-hand with having anxiety disorder.

It took a LOT of therapy for me to get to the point where I could break down a situation into a step-by-step process rather than see it as this giant, tangled mess of impossible-to-solve issues. It's stupidly difficult to remove yourself emotionally from a situation and look at things entirely objectively!

My trick of getting through feeling overwhelmed is to take my time thinking about what I want to do, and just take that one step in the direction that makes the most sense. And then I honestly just do that over and over again. It sounds overly simple, but it honestly works.

Sometimes I have to ask for advice. We all need a helping hand every once in a while, and sometimes all we need is another person's perspective.

things can change

And when you have a LOT going on at once, it definitely can feel like tiny steps aren't enough, especially when it takes you so long to finish one small task. The truth is, though, that progress adds up. Small steps lead to big accomplishments. I have to remind myself every time I feel discouraged that I don't get anywhere if I don't AT LEAST try. Have you looked back recently and seen how far you have come? I bet you that you've made lots of progress in many ways. I bet you've survived lots of things that at the time felt impossible to get through.

It's also super important to not label things as IMPOSSIBLE, I.E. "This can't be done because ____," "I know I am not capable of ____," "I don't know how to ____, so I won't even try." This is a depression symptom that often shows up with severe anxiety. It's stupid and doesn't know anything about what you're capable of.

How I Deal with Feeling Overwhelmed:

1. STOP. Breathe. Get your heartrate back to normal. Have a good cry if necessary. (Seriously. It helps.)

2. Simplify. What is the overall goal for RIGHT NOW? What is the first step?

3. Cut out whatever is unnecessary. Learn to say no. Set boundaries with yourself and others. Budget your time and focus.

4. Take a break if you need it. We ALL need rest days. If you don't take time to recharge, you are going to burn out.

5. Recognize progress and reward yourself!

The important thing for me to see is that I can't allow myself to get bogged down by anxiety and fear. If I want a life worth living, I HAVE to face the things that make me feel unsafe and overwhelmed. I have to challenge the status quo.

Being overwhelmed is a sign that we are trying. Being overwhelmed shows that you are not content to remain stagnant. Being overwhelmed is an indication that it's time for some healthy changes to take place.

just try

IT'S OKAY IF IT'S NOT AS GOOD
AS YESTERDAY

Future you can handle her own problems.

YOU HANDLE TODAY.

You are capable.
You can do this.

Just
one step
at a time.
You got
this.

you
can
do the
thing!

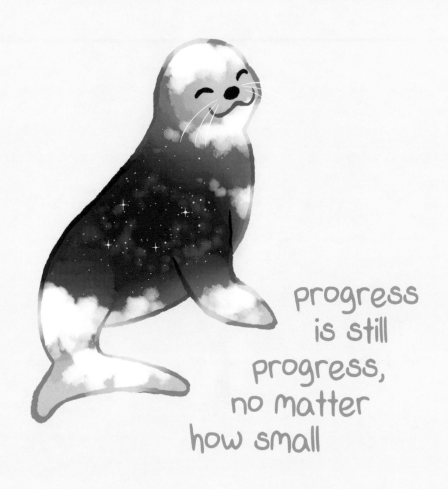

progress
is still
progress,
no matter
how small

you are trying,

and that's what matters

Whatever you manage to
do today will be enough.

Trying your best is all that matters. The rest will fall into place.

your speed
doesn't matter,
forward
is
forward

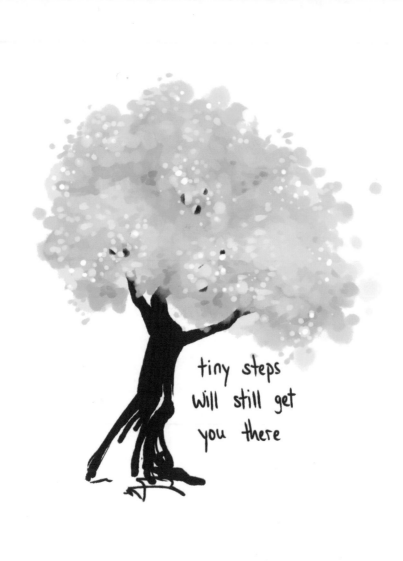

tiny steps will still get you there

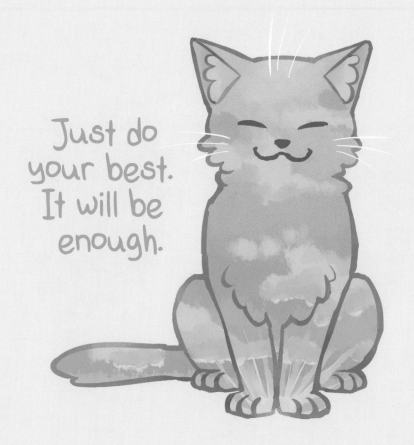

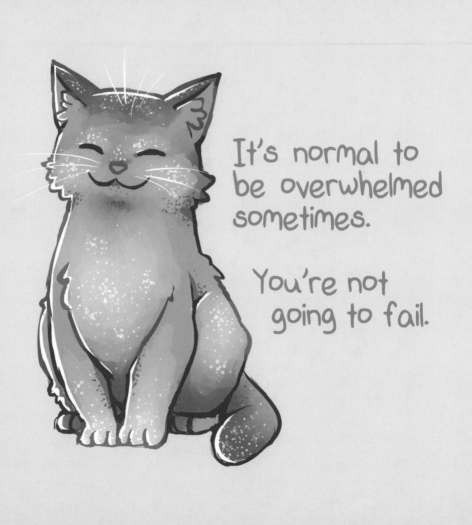

It's normal to be overwhelmed sometimes.

You're not going to fail.

There's no rule that says you have to have everything figured out right now. Every step forward is progress.

It's okay to take things on as you feel ready. You don't have to be your ultimate self right now.

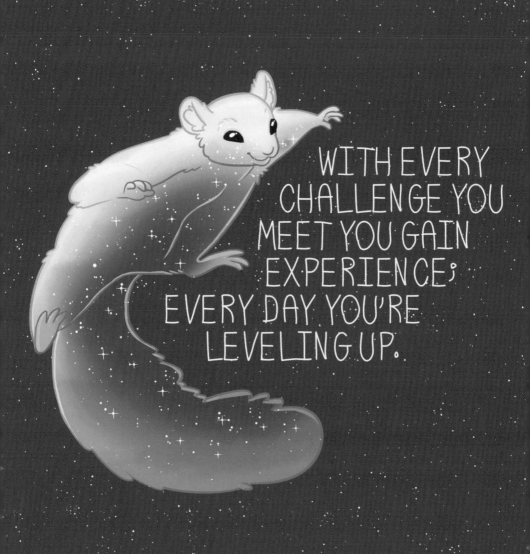

WITH EVERY CHALLENGE YOU MEET YOU GAIN EXPERIENCE; EVERY DAY YOU'RE LEVELING UP.

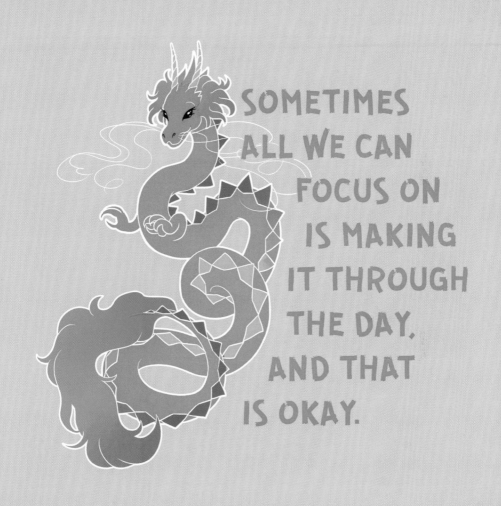

SOMETIMES ALL WE CAN FOCUS ON IS MAKING IT THROUGH THE DAY, AND THAT IS OKAY.

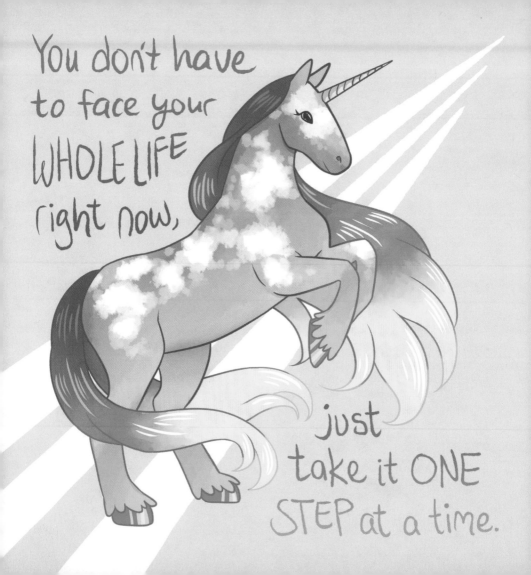

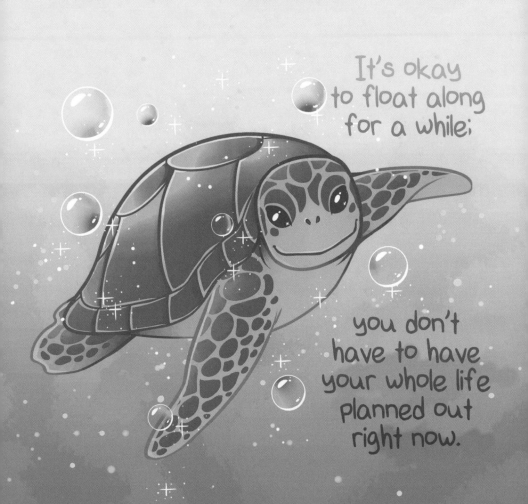

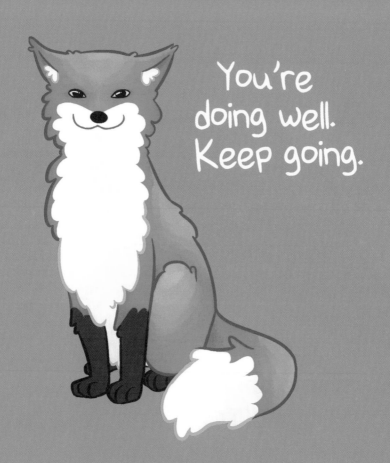

You're
doing well.
Keep going.

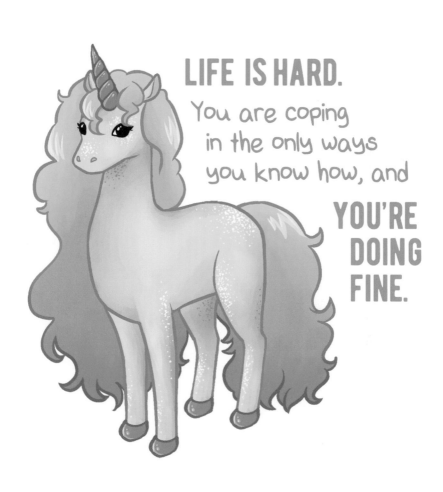

LIFE IS HARD. You are coping in the only ways you know how, and YOU'RE DOING FINE.

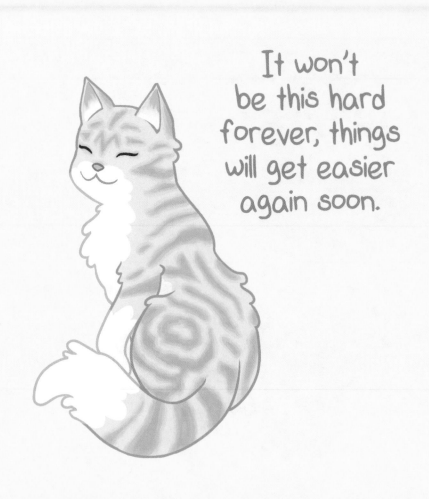

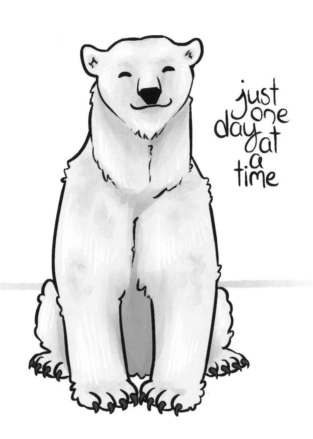

just one
day at
a
time

You're trying so hard.
That means something.

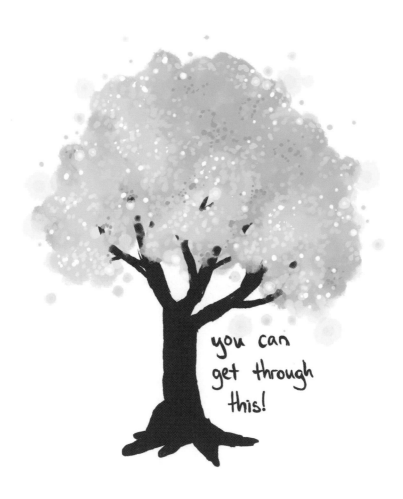

you can
get through
this!

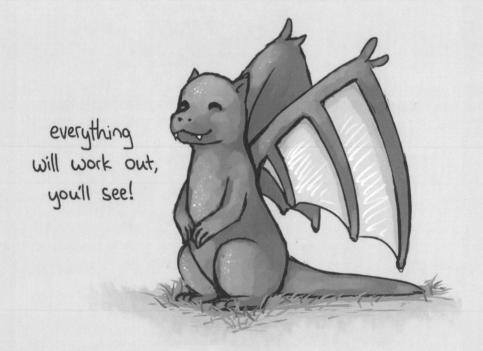

If you are struggling with feeling overwhelmed, I invite you to try one of these coping strategies that have worked for me:

Do (Only) Your Best
Don't aim for perfection;
aim for what you
can manage

Take Deep Breaths
Breathe slowly so
your tummy goes up
and down

Simplify
Focus ONLY on what
needs to be done TODAY

You need to give
yourself time to heal,

no matter how long that
ends up being.

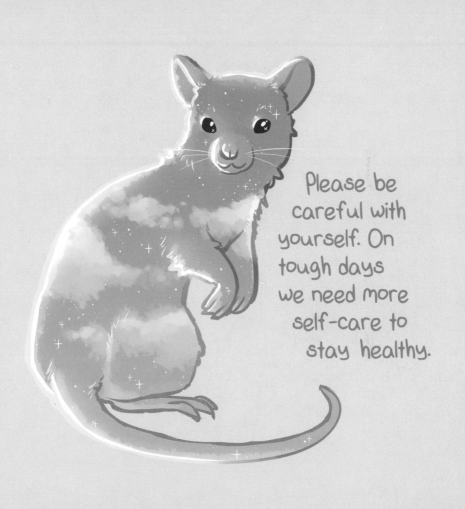

Please be careful with yourself. On tough days we need more self-care to stay healthy.

please take time to
recharge yourself today

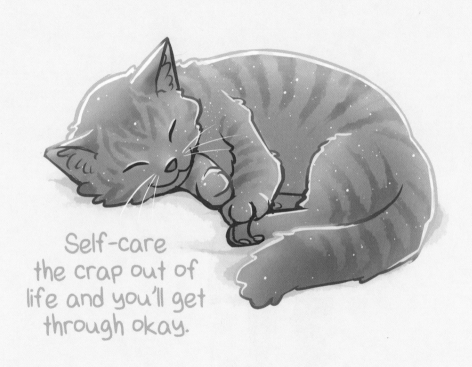

Self-care
the crap out of
life and you'll get
through okay.

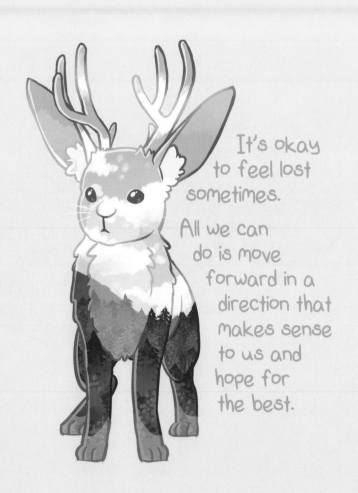

It's okay to feel lost sometimes.

All we can do is move forward in a direction that makes sense to us and hope for the best.

It's okay to want to be alone.
It's okay to take time for
yourself.

CHAPTER 5

I'm Feeling Hopeless

Alright, so first off. Feeling hopeless is just a misbehaving brain doing misbehaving brain stuff. It's like a bug, a glitch.

When I'm feeling hopeless I have to IMMEDIATELY mentally stamp "YOU ARE DEPRESSED. THIS IS DEPRESSION." It's such an insidious thing that can paint your problems as insurmountable, that you are completely stuck in this situation, and there is only pain on the horizon.

I now realize after going through years of therapy that feeling hopeless is just a sign that my mental fortitude has slipped and that my chosen coping strategies are not meeting my challenges adequately. So, hopelessness is not a signal that life is bad or that my problems are impossible. It's just a weirdly dramatic notification from my brain that I am not keeping up my self-care, and that I need to reach out and connect with somebody.

I have not been sleeping well lately.

My MOST IMPORTANT Mental Health Checklist:

1. Did you sleep well?

2. Have you eaten?

3. Did you connect with anyone today?

If the answers to any of these are "no," I know I then need to be more careful with myself. It's a signal that my defenses are down, and it takes little for my mental health to spiral into severe depression.

Welcome to the experience of life! You will spend half of your mental energy babysitting your brain.

It's true, however, that categorizing and ordering your mind doesn't erase the emotional effects. So, if you're feeling hopeless right now, please know that you will make it through this. EVERY TIME you have felt that life was hopeless, you've come out the other side and had good times again.

EXHALE. TAKE A DEEP BREATH.

Many people have survived
exactly what you are now facing.

You are not alone, and you are
just as strong as they were.

YOU WILL SURVIVE THIS.

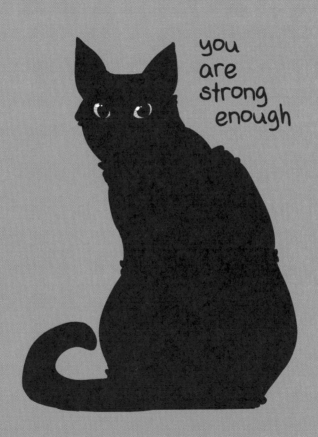

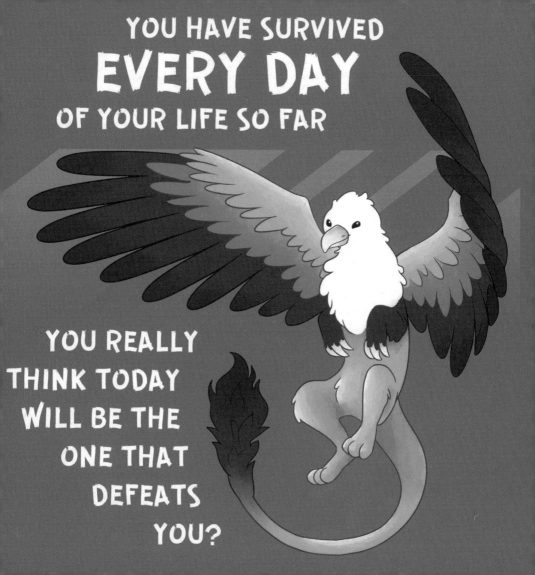

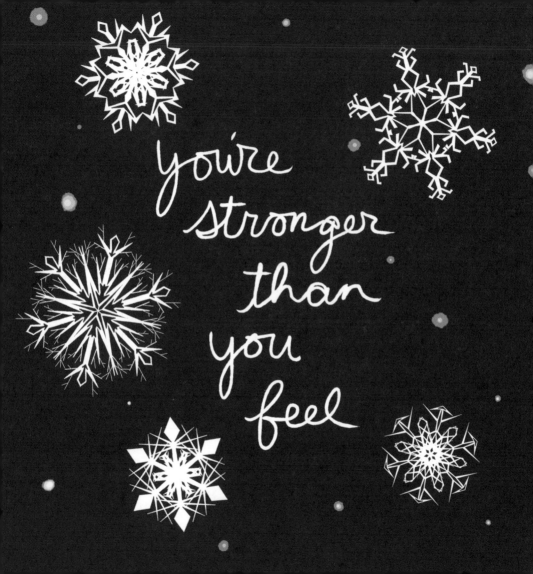

All difficult days end.
You will get through this.

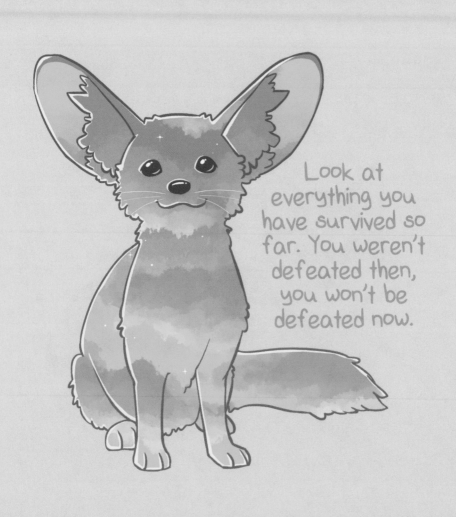

Look at everything you have survived so far. You weren't defeated then, you won't be defeated now.

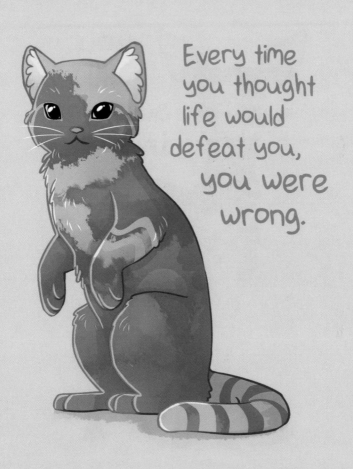

Every time
you thought
life would
defeat you,
you were
wrong.

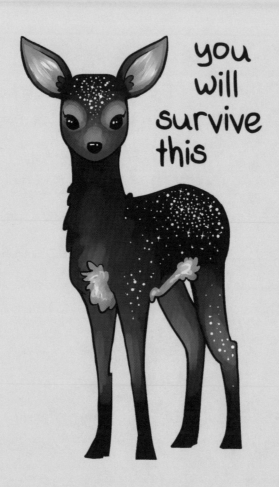

you
will
survive
this

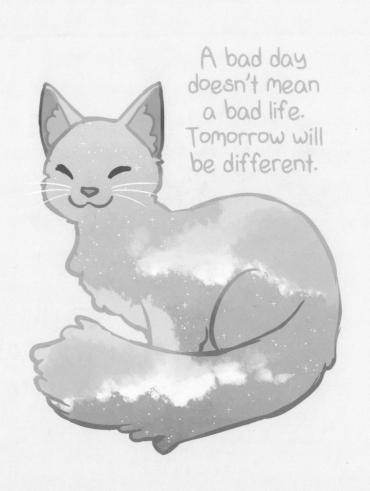

A bad day
doesn't mean
a bad life.
Tomorrow will
be different.

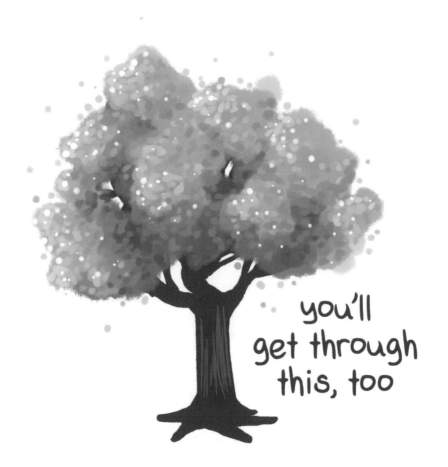

you'll get through this, too

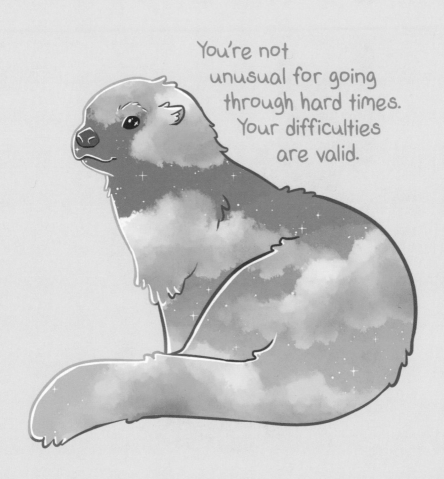

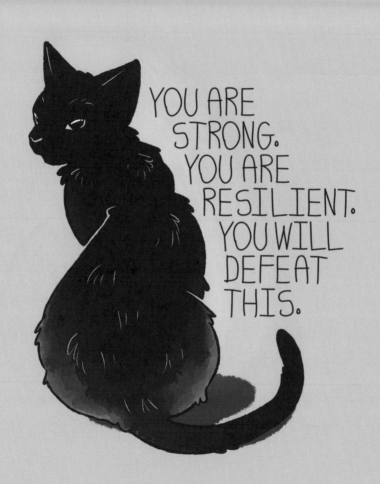

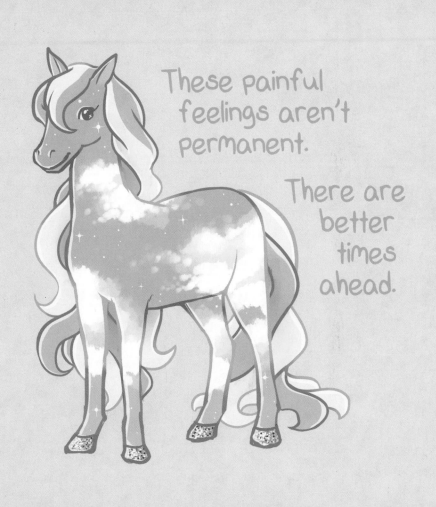

These painful feelings aren't permanent.

There are better times ahead.

No hardship lasts forever.

There
are better times ahead.

you are strong enough

HURT IS NOT THE SAME AS HOPELESS.

NO AMOUNT OF SADNESS OR SICKNESS CAN SWALLOW THE LIGHT INSIDE OF US.

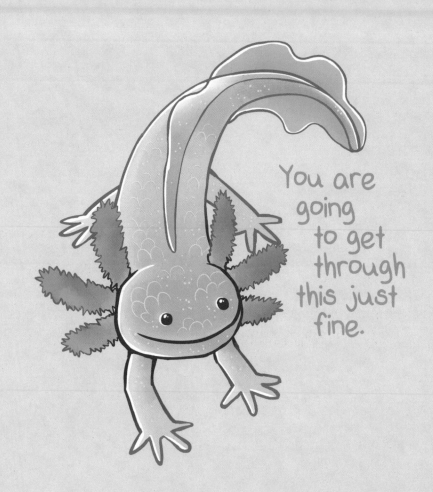

You are
going
to get
through
this just
fine.

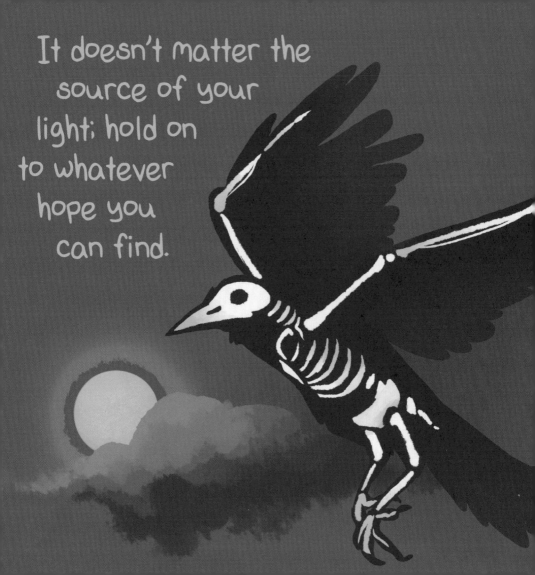

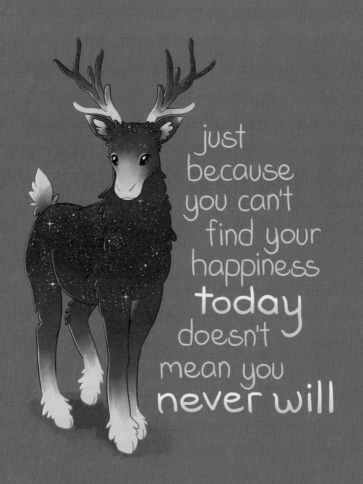

just
because
you can't
find your
happiness
today
doesn't
mean you
never will

some days
are awful,
but they
always
end

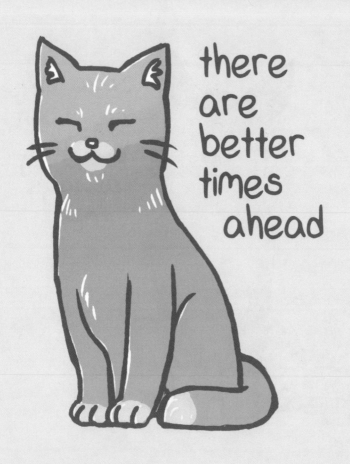

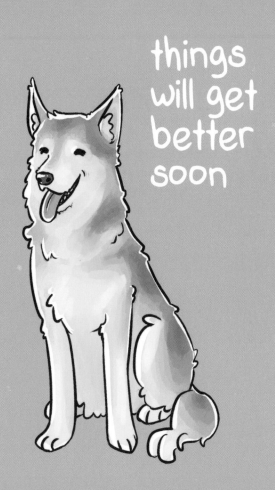

things
will get
better
soon

If you are struggling with feeling hopeless, I invite you to try one of these coping strategies that have worked for me:

Have a Good Cry

Your brain releases
chemicals that can
sometimes help you
feel better

**Dont Try to Fix
Anything Right Now**

Make getting through
the day your #1 priority

**Make a List of Things
You Haven't Tried Yet**

Trying new things
will bring you a
new perspective

those who don't respect you
don't deserve you.

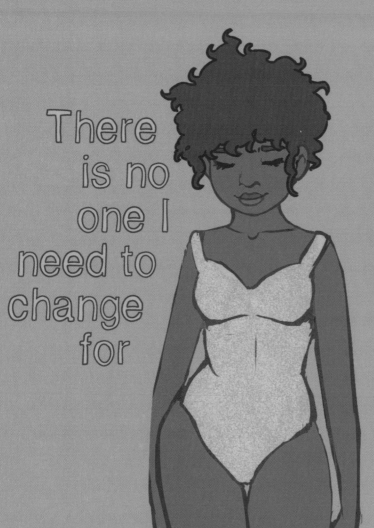

A person doesn't have to be bad to be bad for you.

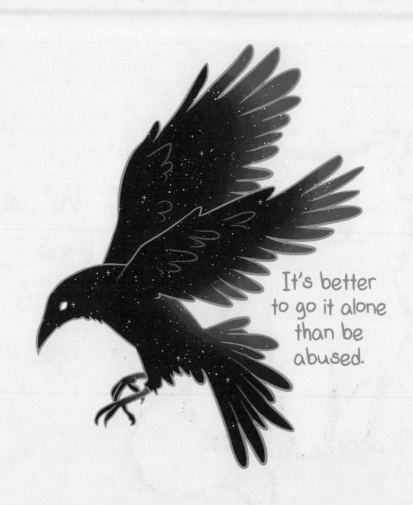

It's better
to go it alone
than be
abused.

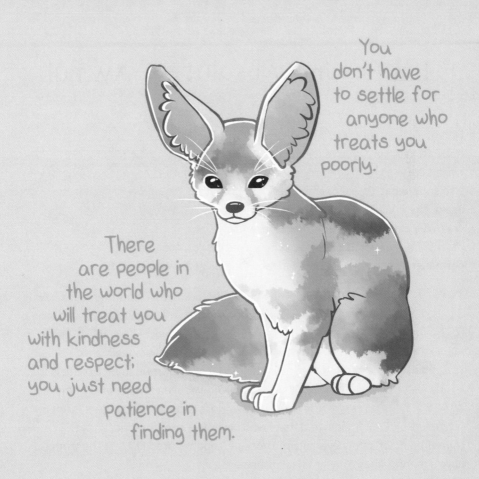

You don't have to settle for anyone who treats you poorly.

There are people in the world who will treat you with kindness and respect; you just need patience in finding them.

CHAPTER 6

I'm Feeling Absolutely Awful

First of all, if you are reading this because you feel horrible, I am sorry you're feeling this way. I do know what it is like to feel like everything is falling apart, but I also know what it's like to come back out of that again. The thing about hitting rock bottom is that it ALWAYS points to another issue; it never truly means the situation is hopeless. It never means you are permanently stuck. And it never means that life gets worse from here.

For me personally, hitting rock bottom means having suicidal ideation (experiencing suicidal thoughts or being mentally preoccupied with suicide). This ALWAYS comes up when I am feeling very overwhelmed. The important thing to note is that it's ALL TEMPORARY; even though every time it feels like the world is ending, that all there is left is pain and that I won't ever feel connectedness, love, contentment, or safety ever again. Those perceptions are ALL LIES. The truth is I have a mental illness; my brain is misbehaving.

The first time I experienced suicidal ideation was when I was thirteen years old. It was as if as soon as my brain could form the chemicals to make that noxious concoction, it started pumping it out immediately. So, while I carefully put on a smiling face, from puberty on I contemplated ending my life regularly.

I ended up hospitalized at eighteen. While the hospital visit wasn't all that helpful, it did put things in perspective for me. I realized that if I wanted to end my life this badly, before I did anything permanent, I needed to try really hard to change my life. I needed to really try to make a life that I thought was worth living.

every awful time ends, including this one

Everyone has to find their own reason for continuing on. For me it was not wanting to hurt anyone as well as having a small determination to build a life that I could actually enjoy. Perhaps it was possible to create a reality I didn't want to escape from.

The important thing to recognize right now if you're experiencing suicidal ideation is that your current job is survival, and you need to seek out whatever will help you do that, whether it's being very candid with a friend, using a chat service, or calling a hotline. It's time to set aside all other tasks and goals in order to keep yourself going.

YOU DESERVE TO SEE TOMORROW. And it will not be as terrible as your mind says, I promise.

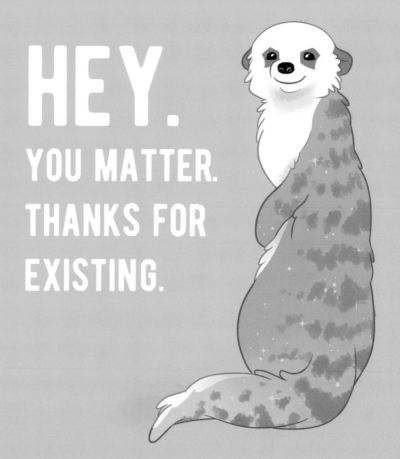

HEY.
YOU MATTER.
THANKS FOR
EXISTING.

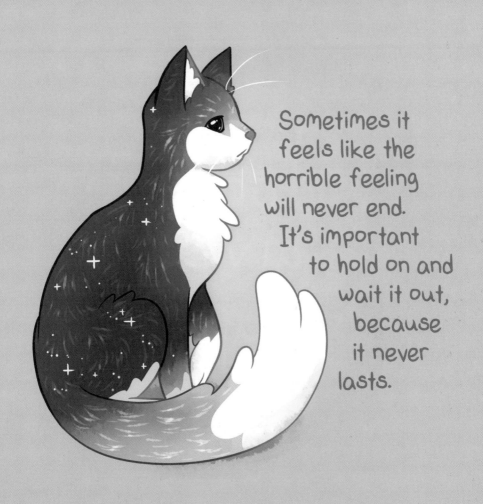

Sometimes it feels like the horrible feeling will never end. It's important to hold on and wait it out, because it never lasts.

don't
give
up

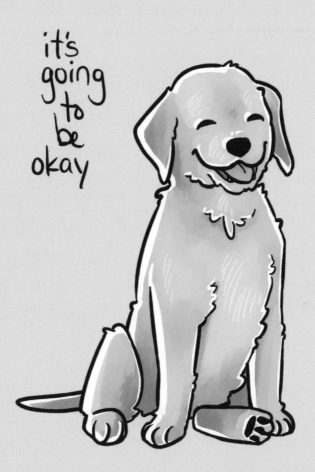

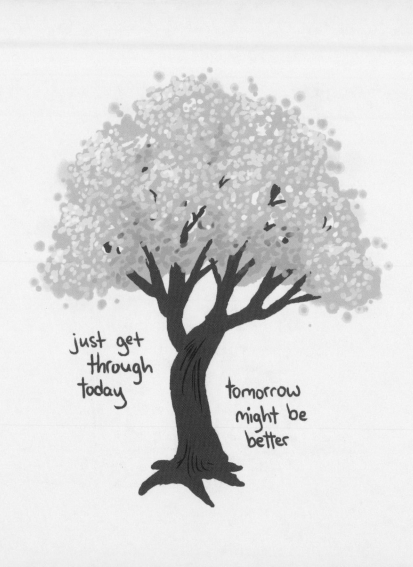

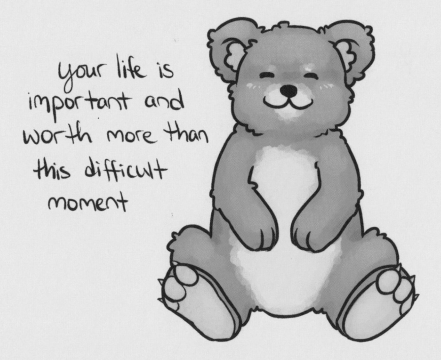

your life is important and worth more than this difficult moment

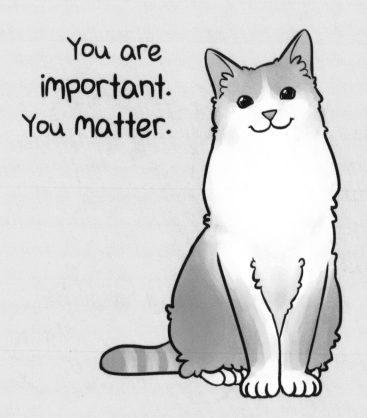

Everything changes,
nothing is permanent.

Don't throw your life away for
a temporarily terrible time.

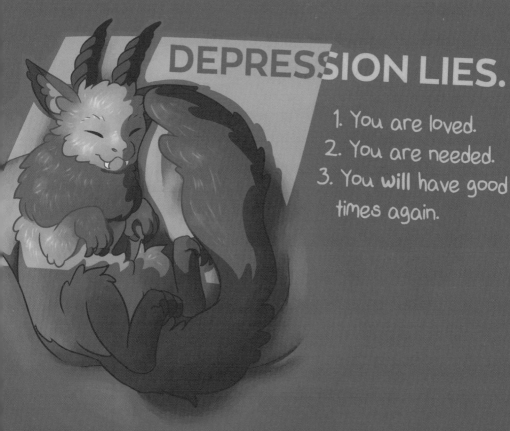

DEPRESSION LIES.

1. You are loved.
2. You are needed.
3. You **will** have good times again.

You
deserve
to be here.

Times may be bad, but that doesn't mean things can't get better.

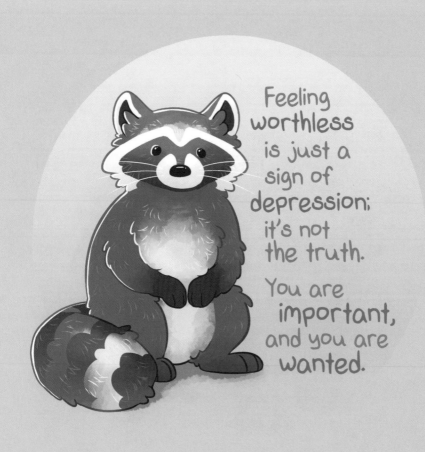

Feeling worthless is just a sign of depression; it's not the truth.

You are important, and you are wanted.

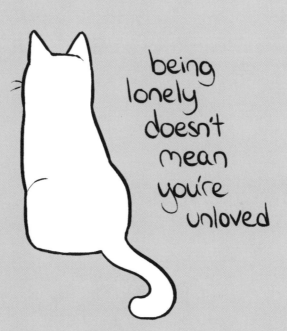

being
lonely
doesn't
mean
you're
unloved

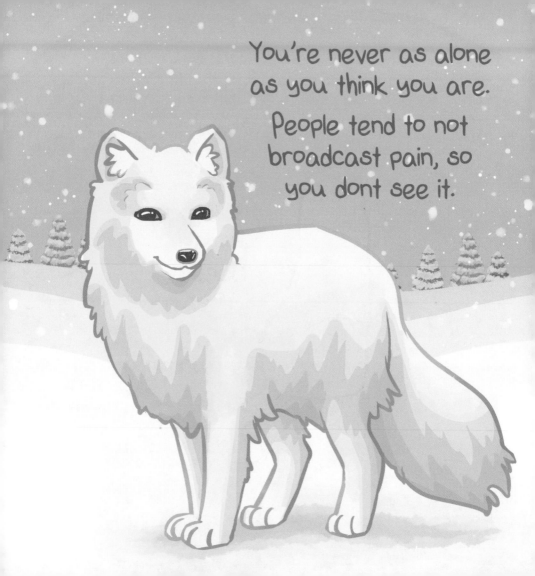

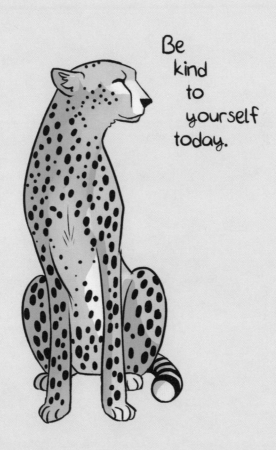

Be
kind
to
yourself
today.

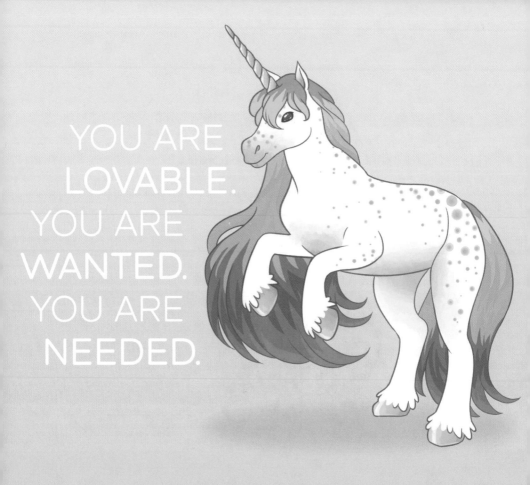

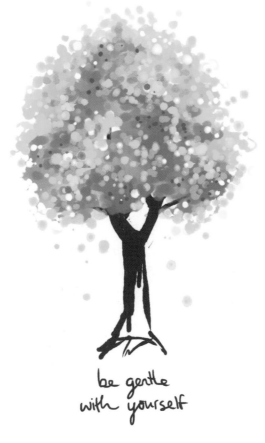

be gentle
with yourself

you
are
worth
taking
care
of

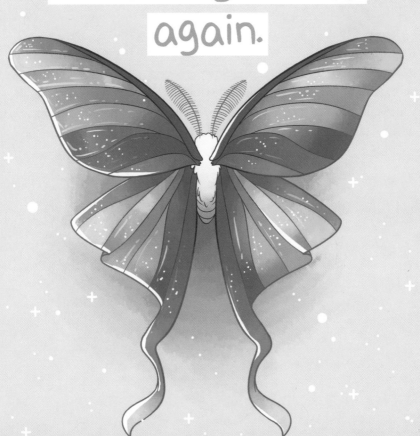

If you are struggling with suicidal ideation, I invite you to try one of these coping strategies that have worked for me:

Talk Back
Be your own
defense attorney

Mindfully Observe
Watch the thoughts and
feelings pass by

Soothe Yourself
Comfort yourself as you
would a friend

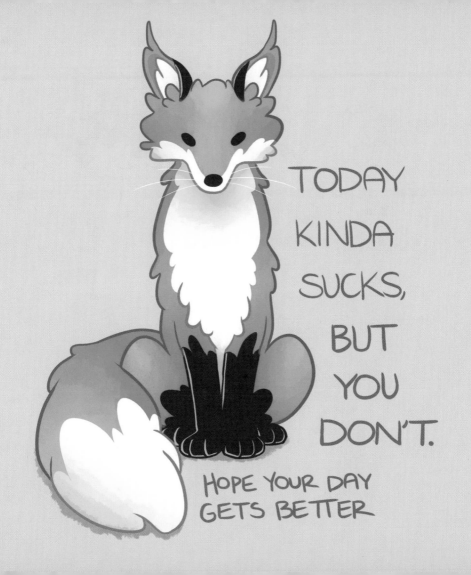

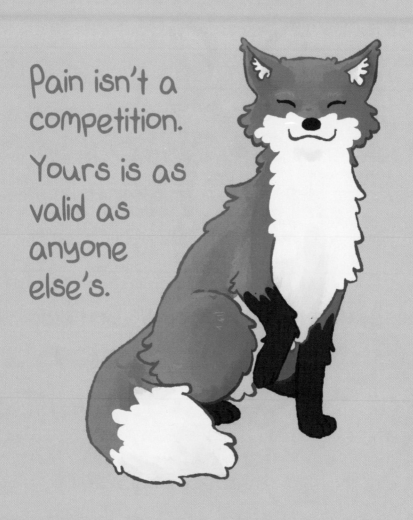

Pain isn't a competition. Yours is as valid as anyone else's.

YOU
WILL
SURVIVE
THIS

You've come so far.

I'm proud of you.

Conclusion

Remember that you are more than a string of bad days or hard time. One mistake doesn't spoil everything you've done or could do. I would like to invite you, any time you feel like it would be helpful, to return to this book and look through it. It's another tool in your coping toolbox now.

And if your coping toolbox is feeling particularly empty, here is a list of self-care ideas that I've found personally helpful:

1. Lighting a few candles or stringing up some twinkle lights

2. Creating, whether it's drawing, baking, or writing a love note to someone I care about

3. Organizing, decluttering a specific space, or cleaning

4. Taking a bath or a long shower

5. This ritual: breathe deep, close your eyes, relax your jaw, stretch, and let out a BIG sigh

I draw encouraging animals for myself, but I'm always happy to hear when others have found comfort in them. I would love to hear from you on any of my social media platforms, so please stop by and share your story with me.

Thank you for continuing to fight! I am rooting for you.

All My Best,
Kate Allan (TheLatestKate)

Kate Allan

Kate Allan is an author, artist, and the creator of the mental health art blog, The Latest Kate. She draws and writes with gentle comfort and encouragement about the trials and tribulations of life. A Southern California transplant, she enjoys anything bright, fluffy, or colorful, as can be seen in her work. When she isn't endeavoring to soak up every ray of sunshine, she works as a freelance designer and illustrator.

Twitter: @tlkateart
Instagram: @thelatestkate
Blog: thelatestkate.tumblr.com
FB: facebook.com/thelatestkate